Burma Campaign UK and **Louise Chantal** present

Red Fighting Peacock Productions in

D1100177

The Lady of Burma

Written and directed by **Richard Shannon**
Featuring **Liana Mau Tan Gould** as Aung San Suu Kyi

First previewed as part of a Gala presentation at the Old Vic Theatre, London on 12 November 2006

First performance at the Edinburgh Festival Fringe 2007 on 3 August 2007 at Assembly@St George's West

Foreword from Archbishop Emeritus Desmond Tutu on Aung San Suu Kyi

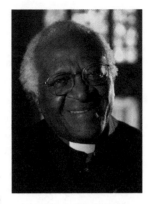

She is my pin-up! I have two pictures of her in my office. One, a photograph taken during her last period of freedom. The other, a very beautiful one, sent to me by my dear sister herself. She inspires me with her gentle determination. In the face of the viciousness of the military regime, who so callously refused to let her dying husband visit her to say goodbye… she has demonstrated just how potent goodness is. Men, armed to the teeth, are running scared of her. When those men are no more than the flotsam and jetsam of history her name will be emblazoned in letters of gold. She has already won, and they know they have lost.

I love her, and I am in awe of her.

God bless her.

ARCHBISHOP EMERITUS DESMOND TUTU

From the director

When I was at university, I acted in a Fay Weldon piece – *Mr Director*. One of the cast members was a young woman called Pippa Curwen. She was Burmese.

We lost touch when we all went our separate ways, but this friendship kindled an interest in Burma; but other than reading the news, I did nothing concrete to support the cause of democracy.

Last year, I met an actress at Polka Theatre, where I work as the Associate Director dealing with new work. Liana Mau Tan Gould had just given a wonderful performance in a powerful new play about the Vietnamese boat people, directed by Scott Graham from Frantic Assembly.

I was immediately struck by her resemblance to Aung San Suu Kyi and wondered if anyone had written a play about The Lady, and if not, how such a play might help the campaign to get her released from house arrest.

I emailed Vera Baird MP, who then was heading the Burma group in Parliament. She wrote back immediately saying the idea was very timely. I decided I had to try to write a play about The Lady.

From the moment I made this decision, I have been overwhelmed by the support the project has received.

The Burma Campaign took up the proposal with great energy, and in short order, we received money to float the production from some very well-known artists.

The Arts Council then awarded me a grant to go to Burma and to work with two outstanding dramaturges to develop the text. The technical staff at the Old Vic offered their time and expertise free, and finally a number of very prominent supporters of the Burma Campaign pledged to take part in the event.

I was privileged to have access to people close to Aung San Suu Kyi and to a number of Burmese political refugees, who had taken a leading part in the uprising of 1988. The play draws on their testimony as well as Aung San Suu Kyi's own words.

I have tried to represent her views as accurately as possible, whilst at the same time painting a portrait of a human being who has lived through tragedy and has made great sacrifices for her people. Although I am sure

she would brush aside such a description, I hope that she might feel the attempt was worth it.

The play is set in the aftermath of the Depayin incident – the assassination attempt in May 2003. Aung San Suu Kyi has survived the attack in which one hundred of her young followers were beaten to death. The play takes place in her cell in the hospital wing of Insein prison and is a journey into her memories.

The creation of this play has been an extraordinary journey. After 26 years, I am now back in touch with Pippa Curwen, who is working with refugees on the Thai-Burma border, and the play has been read in many countries around the world, to mark Suu's birthday on 19 June this year, including a landmark reading at the House of Commons.

I hope that the heroic story of Aung San Suu Kyi will go on to reach an even wider audience, adding to the momentum that will one day lead to her release and the return of democracy to Burma.

RICHARD SHANNON
WRITER & DIRECTOR

Biography of Aung San Suu Kyi

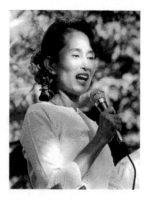

Aung San Suu Kyi (pronounced 'Ong San Soo Chee') is the leader of Burma's pro-democracy movement. She is now in her 12th year of detention. She isn't allowed to see family or friends as all visitors are banned. Her phone line is cut and her post is intercepted.

She was born on 19 June 1945. She is the daughter of General Aung San, who led the struggle for Burma's independence. Aung San was assassinated when she was only two years old.

Aung San Suu Kyi was educated in Burma, India and the United Kingdom. While studying at St Hugh's College, Oxford, she met Michael Aris, a Tibet scholar, whom she married in 1972. They had two sons, Alexander and Kim.

She returned to Burma in 1988 to nurse her dying mother and was immediately caught up in the country's democracy uprising against the military dictatorship led by General Ne Win. Joining the newly formed National League for Democracy (NLD), Suu Kyi gave numerous speeches calling for freedom and democracy. The Junta crushed the protests with ruthless brutality, murdering up to 5000 people.

Nevertheless, the uprising had underlined the military government's lack of legitimacy, and the generals decided to hold an election which they thought they could win through bribery and intimidation.

Suu Kyi campaigned on behalf of the NLD and soon made a name for herself. The regime recognised the threat she posed and placed her under house arrest and other members of the NLD in jail. Despite this, the NLD won 82% of the seats in Parliament. The Junta simply ignored the results.

On 27 March 1999, Suu Kyi's husband, Michael Aris, died of prostate cancer in London. He had requested a visa in order to visit his wife. The Burmese regime refused his request.

Aung San Suu Kyi has now spent nearly 12 years under house arrest. Although the regime have released her periodically, she has always been re-arrested.

She was last returned to house arrest in May 2003, after the regime attempted to assassinate her near the village of Depayin. One hundred of her supporters were beaten to death in this incident. Suu Kyi sustained multiple injuries during the attack and was held in the hospital wing of Insein jail for some time.

Aung San Suu Kyi has won a number of important international awards, including the Nobel Peace Prize, the Sakharov Prize and the United States Presidential Medal of Freedom.

She has called on people around the world to join in the struggle for freedom in Burma – 'Use your liberty to promote ours!'

The Lady of Burma

Liana Mau Tan Gould as Aung San Suu Kyi

Written and directed by **Richard Shannon**
Designed by **Polly Sullivan**
Lighting by **Gerry Jenkinson**
Sound design by **John Mills**
Dramaturgy by **Paul Sirett** & **Hanna Slättne**

Company Stage Manager **Susie Schutt**

Produced by **Louise Chantal**

(production and press enquiries to louisejchantal@aol.com / 07976 418232)

The writer wishes to thank: John Mills, Brian McAvera and Stranmillis University College, Paul Sirett, Hanna Slättne, Lucinda Phillips, Ko Aung, Nita May OBE, Deborah Quare and St Hugh's College, Oxford, Dr Ann Pasternak-Slater, St Anne's College, Oxford, Lady Gore Booth, Jane Drinkwater, Guy Horton, Dr Win Naing, The Burma Campaign UK, Alex Fox, Polka Theatre, Felicity Ford – CSV Media and Ian Rimington and the Arts Council – London Office.

The producer wishes to thank: Everyone at Burma Campaign UK especially Suki Desanj, whose enthusiasm and dedication has been imperative to the success of this production; Assembly Theatre, Oberon Books, Liz Smith and Moira Gibson, James Seabright and Sean Hinds.

Biographies

Liana Mau Tan Gould
Aung San Suu Kyi

Liana trained at the Guildford School of Acting. Theatre includes: *Read, Steady Write!* (Soho Theatre); *Lear's Daughters* (Soho Theatre and tour); *SMACK* (Etcetera Theatre); *Urban Stories* (Riverside Studios and tour); Rep Season for Ian Dickens Productions which included *Sailor Beware*, *Our Day Out*, *Hay Fever*, *Seasons Greetings*, *The Dresser* and *Aladdin*. Short film and television credits include: *The Shadow* (Culturevulture Prods); *The Ginger Tree* (BBC); *Phil learns to Curse* (TR Productions); *The Black Chador* (F4Films).

Following on from the overwhelming response at the Old Vic, Liana is very proud, once again, to be able to perform *The Lady of Burma* and hopes the 'light from the furthest star falls on this earth' and that Suu Kyi and her people's desire for 'Freedom from Fear' will be a reality one day soon.

Richard Shannon
Writer & Director

Richard Shannon read English at New College, Oxford, and studied theatre direction at the Bristol Old Vic Theatre School. He is currently Associate Director (New Work) at Polka Theatre.

His productions at Polka include: *Shouting, Stamping and Singing Home* by Lisa Evans, *Bear Stories* by Martin Waddell, *Boy* – the boyhood of Roald Dahl by Mike Kenny, *Christmas Carol* at the Mansion House, *A Pallace of Gold* by Richard Shannon at the Guild Hall and *Dazzling Medusa* by Geraldine McCaughrean. Richard has directed for the BAC, The Cockpit, the Young Vic, Commonstock Theatre company and a showcase of new work at the Cottesloe (Royal National Theatre).

Richard was co-director of Independent Radio Drama Productions, based at LBC Radio. His production of Paul Sirett's *Vissi D'Arte* was Highly Commended at the Prix Italia. He has directed work by Simon Beaufoy and Martin McDonagh and a number of classic serials for National Public Radio (USA) including *The Hound of the Baskervilles* starring Edward Petherbridge and *Dracula* starring Don Henderson and Kenneth Haigh. For IRDP, Richard has written over 30 radio plays and his stage plays include: *Sabbat* (The Actors' Centre), *El Salvador Nativity* (pub. Christian Aid), *Star Gazer* (Polka tour to the US) and *Going Underground* (Commonstock).

His most recent credits as writer/director include: *An Audience with William Barlow (deceased)* a celebration of the work of the Victorian Engineer, William Barlow, starring David Calder (produced by London and Continental Railways for the Architecture Biennale 2006); and *All Our Hellos and Goodbyes* – the story of John Betjeman and the saving of St Pancras station, starring Julian Glover (LCR–2007)

Richard has directed four short films and worked as First Assistant Director on the pilot for the feature film, *The Legend of Billy the Kid*. In 2005, he directed *Chuckwudubelu – Preserved of God* by Justin Butcher, starring Ben Okafor for BBC Radio 4.

Louise Chantal
Producer

Currently the theatre producer and programme consultant at the Assembly Theatres and the Riverside Studios, she has previously worked independently as a producer, PR and marketing consultant, and has been the recipient of two prestigious New Producer Bursaries run by Stage One

and the Society of London Theatres (2004/5). Recent theatre productions include *The Exonerated* at the Riverside Studios, Edinburgh Festival and Dublin International Theatre Festival (cast members included Aidan Quinn, Stockard Channing, Danny Glover, Kristin Davis, Mackenzie Crook, Alanis Morissette and Catherine Tate); *The Odd Couple* with Bill Bailey and Alan Davies (Edinburgh 2005); *Thom Pain (based on nothing)* – Pulitzer Prize finalist 2005, Edinburgh, London and New York; and the multi-award winning American company The Riot Group worldwide.

Polly Sullivan
Designer

Polly trained at Chelsea School of Art and Wimbledon School of Art, graduating in 2003 with a 1st class honours degree in Theatre Design. Polly's most recent credits include: *Called To Account*, dir Nicolas Kent (Tricycle Theatre); *The Atheist*, dir Ari Edelson (Theatre503); *You Might As Well Live*, dir Tim Roseman (New End Theatre); *How Long Is Never? Darfur – A Response*, dirs Nicolas Kent, Indhu Rubasingham, Charlotte Westenra (Tricycle Theatre); *Seduced*, dir Michael Kingsbury (Finborough Theatre); *The Snow Dragon*, dir Toby Mitchell (US tour, UK tour, Soho Theatre); *The 24 Hour Plays Celebrity Fundraiser* (The Old Vic). Forthcoming productions: *Flight Path* (Bush Theatre/Out Of Joint); *A Christmas Carol* (Chickenshed Theatre).

Gerry Jenkinson
Lighting Designer

Theatre credits include: *The Revenger's Tragedy* (RSC, Swan Theatre); *A Woman of No Importance, The White Devil, For Services Rendered, The Elephant Man, Translations, The Duchess of Malfi, School for Wives, Entertaining Strangers* and *The Tempest* (Royal National Theatre). West End credits include: *The Big Life, Semi-Monde, Rupert Street Lonely Hearts Club, Lady Windermere's Fan, Oleanna, The Invisible Man, A Woman of No Importance, The Vortex, Summit Conference, Mother Courage, Torch Song Trilogy, Phaedra, The Normal Heart, The Entertainer, Pal Joey, The Rocky Horror Show* and *Observe the Sons of Ulster Marching Towards the Somme*. Recent theatre credits include: *Yerma* (Arcola Theatre); *Rikki and Me, The Comedy Unit; David Copperfield* (West Yorkshire Playhouse); *Girl With Red Hair* (Edinburgh Lyceum and Hampstead Theatre); *The Big Life* (Theatre Royal Stratford East) and *Two Sisters and a Piano* (Riverside Studios). Among his credits for opera are: *Koanga* (Pegasus Opera); *Hey Persephone!* (Almeida Theatre); *The Barber of Seville*, (Opera North & Scottish Opera) and *Lazarus* (Royal Opera House and Opera North). International credits include the off-Broadway production of *Nothing* and *Travels With My Aunt*.

John Mills
Sound Designer

John's career in theatre spans four decades – with a two-decade hole in the middle. Working initially as a lighting designer, in the early 1970s he lit many of the contemporary dance productions for the nascent Greenwich Festival. Since then he has worked primarily as a freelance radio producer, journalist and trainer in the independent production sector, commercial radio and, most recently, six years with BBC local radio. He now runs Riverfront Media, the radio production and training company. In the mid-1990s he met Richard Shannon and they collaborated on a number of radio drama productions for LBC radio and in 1997 they worked together on the sound design for the National Theatre Studio production of *A River Sutra*. Almost another decade later, Richard approached John to create a complex

and layered sound design for *The Lady of Burma*.

Paul Sirett
Dramaturg

Paul is a playwright and dramaturg. His most recent production was the Olivier-nominated musical *The Big Life*, which transferred from the Theatre Royal Stratford East to the West End. Other productions include: *A Night In Tunisia, Worlds Apart, Crusade, Jamaica House* (all Theatre Royal Stratford East); *Rat Pack Confidential* (Nottingham Playhouse, Bolton Octagon & West End); *Lush Life* (Live Theatre, Newcastle); *This Other Eden* (Lakeside, Gilded Balloon); *Skaville* (Bedlam, Soho Theatre). Awards include: Best Play, Pearson (*Worlds Apart*); Best Production, City Life (*Rat Pack Confidential*); and nominations for TMA, Evening Standard and Olivier awards. Paul's radio play *Vissi D'arte*, directed by Richard Shannon, won awards at the New York International Radio Festival and the Prix Italia. Paul has extensive experience as a dramaturg, working on numerous productions at Soho Theatre and the Royal Shakespeare Company.

Hanna Slättne
Dramaturg

Hanna is a founder member of the Dramaturges' Net-work. She works with new writing, translations and with the development of collaborative processes. Recent productions include: *Girls and Dolls* by Lisa McGee, *Family Plot* by Darragh Carville (for Tinderbox Theatre Company), *Julie* by Zinnie Harris – an adaptation of *Miss Julie* for the National Theatre of Scotland and *Accidental Death of an Anarchist* for Borderline Theatre Company. She has worked on development processes with Ransom Productions, Big Telly, Cahoots N.I., Kabosh and Queen's University, Belfast.

Susie Schutt
Company Stage Manager

Susie is also CSM for *Life in a Marital Institution* at Assembly 2007 and has just stage managed The Footlight Club's award winning production of *A Raisin in the Sun* and Animus Ensemble's production of *Little Shop of Horrors* in Boston, Massachusetts. Previous experience includes Hoipolloi Theatre Company and New International Encounter Theatre Company; ElectricVoiceMusic with the debut of their original opera *Abraham on Trial* at The Junction, Cambridge, and Classworks Theatre's production of *In Limbo* (Edinburgh Fringe Festival). In 2004, she graduated from the University of Michigan, where she pursued her passion by directing *Picasso at the Lapin Agile* and *The Vagina Monologues*. Acting credits at Michigan include Celia (*As You Like It*), Karen (*Dinner with Friends*), Halie (*Buried Child*), and Electra (*Electra*).

The Burma Campaign UK

Burma is ruled by one of the most brutal military dictatorships in the world; a dictatorship charged by the United Nations with a 'crime against humanity' for its systematic abuses of human rights, and condemned internationally for refusing to transfer power to the legally elected Government of the country – the party led by Nobel Peace Laureate Aung San Suu Kyi. Like South African leader Nelson Mandela, Aung San Suu Kyi is a symbol of heroic and courageous resistance in the face of oppression and continues to provide hope and inspiration to those struggling for freedom and democracy.

The Burma Campaign UK is part of a global campaign supporting Burma's democracy movement and is the only national organisation in the UK dedicated to campaigning for human rights and democracy in Burma. Established in 1991, the Burma Campaign UK has built a strong reputation as a source of reliable information and a powerful campaigning and lobbying organisation. Working with campaign partners around the world, we persuaded the United Nations Security Council to start to address the situation in Burma. While the dictatorship in Burma spends half its budget on the military, the population goes without access to proper healthcare, education and food. The Burma Campaign UK has successfully lobbied to ensure increased humanitarian aid to Burma. The regime holds over 1100 political prisoners, many of whom face horrific torture. We work to expose torture and other widespread human rights abuses in Burma, such as slave labour, child soldiers, rape as a weapon of war and ethnic cleansing.

The people of Burma can't speak out without risking imprisonment, torture and even death. You can. Please support the Burma Campaign UK and help the struggle to free Burma.

COMMENDATIONS FOR BCUK

"Thank you for all that you have done to help the cause of democracy in Burma." (Aung San Suu Kyi)

"The Burma Campaign UK plays an essential role in ensuring the media reports what is happening in Burma. The moment anything happens to Aung San Suu Kyi, I can be sure that I'll be getting a phone call or email from the Burma Campaign UK." (Jon Snow, Journalist, *Channel 4 News*)

"I can say with confidence that the Burma Campaign UK is a powerful advocate for Burma's pro-democracy movement in Europe. I urge you to support them in every way possible."
(Sein Win – Prime Minister, exiled National Coalition Government of Burma)

The Burma Campaign UK
28 Charles Square
London N1 6HT
Tel: 020 7324 4710
Email: info@burmacampaign.org.uk
Website: www.burmacampaign.org.uk
The Burma Campaign UK is a Limited company, registered in London No. 3804730

Burma – a country ruled by fear

Burma is ruled by one of the most brutal dictatorships in the world. It spends half its budget on the military while the population goes without access to proper healthcare, education and food. One in ten babies die before their fifth birthday.

Elections were held in 1990, and the National League for Democracy, led by Nobel Peace Prize winner Aung San Suu Kyi, won 82% of seats in parliament. The regime refused to hand over power, and instead unleashed a new wave of oppression.

Torture: There are at least 1,100 political prisoners in Burma. Once in prison they face horrific torture, including electric shocks, rape, iron rods rubbed on their shins until the flesh rubs off and severe beatings.

Child Soldiers: Burma has more child soldiers than any other country in the world. Children as young as 11 are snatched by soldiers on their way home from school and forced to join the army. Often their parents are not told what has happened.

Ethnic Cleansing: The regime has been waging war against ethnic minorities, such as the Karen, Karenni and Shan, for decades, driving hundreds of thousands of people from their homes. More than 2,800 villages have been destroyed and countless civilians killed.

Slave Labour: Across Burma thousands of men, women and children have been forced to work for the regime without pay and under threat of beatings, torture, rape and murder. People are forced to work as construction workers or as porters for the army. Porters are also used as human minesweepers, made to walk in front of soldiers in areas where there are landmines.

Rape: The Burma Army uses rape as a weapon of war against ethnic women and children. Rape is regularly committed by officers in front of their troops and often involves extreme brutality, torture, and even death.

FREEDOM FROM FEAR

Aung San Suu Kyi is a symbol of heroic and peaceful resistance in the face of oppression. Known to many of her followers simply as 'The Lady', she has spent more than 11 years under house arrest. Aung San Suu Kyi's message is a simple one – that only by fighting fear can you truly be free – a message Burma's military fears and aims to silence.

THE LADY OF BURMA

Richard Shannon

THE LADY OF BURMA

The story of Aung San Suu Kyi

OBERON BOOKS
LONDON

First published in 2007 by Oberon Books Ltd
521 Caledonian Road, London N7 9RH
Tel: 020 7607 3637 / Fax: 020 7607 3629
e-mail: info@oberonbooks.com
www.oberonbooks.com

A catalogue record for this book is available from the British Library.

ISBN: 1 84002 786 X / 978-1-84002-786-0

Cover image: www.snowcreative.co.uk

Printed in Great Britain by Antony Rowe Ltd, Chippenham.

To my grandparents – Paul and Kathleen Schechner

Characters

AUNG SAN SUU KYI

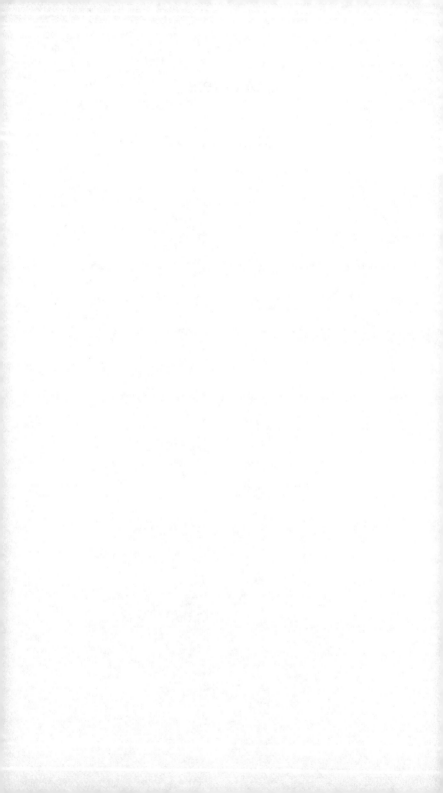

A dark space.

A woman – AUNG SAN SUU KYI – sits in the centre of a cell, bent forward. She is 60 years old. She sits in front of a rough earthenware bowl, filled with dirty water. Behind the bowl, unseen, is a small bunch of white jasmine.

Suspended behind her is the banner of the NLD – a golden fighting peacock, flying across a red sky. It is torn and tattered, like a battle flag.

She is wrapped in a prison blanket. Under the blanket, she wears a traditional Burmese dress, which is bloodstained and torn.

When AUNG SAN SUU KYI plunges into the past, she relives it – piecing the memories together moment by moment.

She talks directly to the audience from the beginning and to her dead father, mother and husband.

Burmese music cross-fades with the sound of the monsoon, which bleeds into the Depayin attack – blows raining down on the roof of a car. These sounds fade under the first speech.

She looks up, letting the blanket fall. She looks round and rubs her shoulders as if in some pain.

AUNG SAN SUU KYI speaks directly to the audience:

I don't know how long I have been here.

She laughs half-heartedly. She is in pain and weakened by the loss of blood.

I am in Insein.

Rather apt.

She smiles.

Insein – the largest prison in Rangoon…built by the British to last.

I can at last look my colleagues in the eye and share *the Insein experience.*

She laughs.

No one speaks to me.

No mirror, but this bowl of dirty water.

I wonder if my make-up is a little smudged?

She tries to see her image, reflected by the water.

They did something to patch me up, you know… despite the fact I didn't have a penny on me for the bribe.

The bribe.

The favour.

U Tin Oo…he told me a joke once…a joke about bribery… We laughed a great deal.

He told it so well, it stayed with me.

SUU smiles.

Senior General Than Shwe is at a trade conference in Beijing. He is sipping tea with his host, Hu Jintao and the Indian Prime Minister, Shri Atal Bihari Vajpayee. They are all getting on famously.

A very rich businessman joins them. After much backslapping and general bonhomie and far too much tea, each leader had to answer the call of nature…

The businessman follows Hu Jintao… 'I didn't want the others to be privy to this offer…but if you will…' (*She whispers something inaudible.*) '…I will be able to give you this…' And he produces a very large brown paper package. Hu Jintao is outraged… 'How dare you insult me, I would never accept such a blatant bribe!'

Very soon, Shri Atal, the Indian PM, also has to leave the table and is also waylaid by the businessman.

'Ah, Your Excellency…please don't tell the others, but if you thought you might be able to…' (*She whispers something inaudible.*) '…I will give you this…' And he produces an even larger brown paper package. The Indian PM is also outraged and raises his voice… 'How could you begin to suggest that I would accept such a…such an inducement!'

The Indian PM returns, shaking, to the tea table.

Finally Senior General Than Shwe leaves his colleagues and before he can avail himself of the hotel's excellent facilities, is, in his turn, waylaid by the businessman.

'Ah, General, forgive me, I couldn't speak openly in front of the others. But I have a proposal…if you…' (*She whispers something inaudible.*) '…then this package… far more than I would be prepared to offer the others, is yours…'

The general is apoplectic.

'Is this a bribe? How dare you insult me! In Myamar such a thing would never be accepted and I would never accept such a thing…

…but my wife's number is zero, four, five, double six, three…'

SUU laughs.

And so it goes. Money greasing the wheels.

Pause.

Must keep walking. Must exercise.

She gets up and starts to walk slowly – painfully along the walls of her cell

I was able to walk more in my
house – amongst my things.

My old house.
– by the lake. The sunsets…
Now, perhaps it's better.

I am in a prison that does not attempt to hide its face.
Four walls – no view to speak of
– in fact – no view at all.

But…at least the walls are dry…bone dry.
My old house is like a sieve in the Monsoon season.

Mind you, I did manage to keep the rain off the piano.
The piano that no longer works.
Now it simply provides a suitable surface for my
photos.

They never turn out that bulb…I cannot sleep…
and every hour an eye appears in the door to check if
I'm still alive. Alive but imprisoned.

Imprisoned…simply what…what so many of my
closest colleagues take as a condition for the struggle for
democracy.

U Tin Oo once told me that in solitary, he would
conjure up the faces of friends and loved ones and talk
to them and remember the good times.
For though the body is confined the mind may wander
where it will.

 *With a deep intake of breath, SUU decides to conjure her
 father. She addresses him:*

Father…

I am told, I am your image, and truth to tell, I feel we
share so many things.
Thoughts, things you have written – I felt as though I
had written them –

But I hardly knew you. Bogyoke Aun San – General,
founder of Free Burma –
Assassinated.
Gunned down in a storm of bullets – 19th July 1947.
I was two years old.

I think I remember running into your arms with my
younger brother – Aung Li – and being hoisted up
and smothered with kisses – but, I know I was told
this…so…?
But I do have a doll – a doll you bought in England
– large, china faced, blue eyed with exaggerated
freckles, whose eyes shut the moment I laid her down
– a most obedient child.

Father – how often have I hoped to feel…to tell you…
That despite all the set backs, the smashed dreams, the
death…
There are many, many good souls who have not
betrayed your dream – democratic
Burma – free under the Law.

You know, I used to almost quiver with pride on
Martyr's Day – standing next to mother, head bowed.

I remember – it must have been '86 or '87 –

SUU enters the memory.

Mother is unusually silent –
– her hands grip the arms of her chair –

(*As her mother.*) 'Ne Win has gone mad! Our resident
Dictator, this absurd playboy – is insane – he is
convinced someone is going to assassinate him and
has taken to shooting himself in the mirror, whilst
trampling on a bag of raw meat.'

SUU laughs.

Magic won't save him Mother.

He is the new King Thibaw – ready to tie us all up
in red velvet sacks and send the royal elephants to
trample us to pulp.

(*As her mother.*) 'This is not a laughing matter. Things are
going to get worse – a lot worse.'

She was right, of course.
Ne Win destroyed the currency.
Ne Win, a postal clerk who joined your army – with the
nom de guerre 'Brilliant – like the sun'.

– Overnight, Ne Win reshaped the kyat and wiped out
people's savings – all in order to create a new coinage
based on his lucky number 9. Can you imagine!

(*To audience.*) But I had other concerns.

> *She touches her head as if in pain and takes a moment
> before…*

I had other concerns.

> *SUU enters the memory.*

I am sitting at home in Oxford, when the phone rings.

Mother has had a massive stroke – Daw Khin Kyi is
suddenly blind and unable to move. I pack a bag and
am in Burma the next day.

Oh Michael, you never once ask me to stay.
You help me pack, drive me to the airport – kiss me
lightly on the forehead – (*In Michael's voice.*) 'See you
soon'.
But then you hug me so tight – so tight as if you would
never release me.

Oh Michael – you always knew that one day, I would
have to go. Mother's illness was only the catalyst.

Do you remember – remember how it all began?

Burma: heat; the sounds of cicadas, light traffic.

SUU enters the memory, sharing it with the audience.

The taxi drops me at the gate. Everything seems
normal – the house – paint peeling in the sun – a few
orchids hanging on and the roses parched.

That rusted metal shutter is open and the door ajar.
I go in.
At first, all I hear is the ticking of the old clock in the
hall.
The house feels empty without Mother's bustling
energy to animate the air.

Then, Maung Htoo, our gardener, pokes his head
round the kitchen door.

(*As Maung Htoo.*) 'Ah, Daw Suu, Daw Suu – nothing is
ready. We weren't expecting you so soon.
Daw Khin Kyi is in hospital. She is…okay.'

I wonder what this platitude conceals and insist he take
me there immediately.

Driving through the streets, something has changed
– you can feel it.
Quite large groups of young people are gathering on
street corners.
Some wearing red headbands – there is the constant
hum of intense conversation.

When I get to the hospital, it takes me an age to find
mother – but finally I squeak my way down one more
corridor and turn a corner and there she is.

She seems shrunken somehow. Tiny – birdlike
– sleeping on her side.
Her breathing is slow, but she is not in pain.
I sink down onto a chair by her bed and hold her hand.

– my mind wandering down the pathways of a long forgotten childhood.

Mother, how you used to chide me –

(*As her mother.*) 'Your father would have expected better of you.

'This is lazy work. He was never lazy. It must be done again.'

Then she would turn very slowly and go out into the garden to tend the roses.

I would stand so still, hot tears of shame filling my eyes. Not only had I disappointed my mother, but also my father. My father who was not there and yet was everywhere.

I went back to my room and curled into a tiny ball. My body sobbing.

And then my mother would come into the room…

(*As her mother.*) 'Tomorrow is another day and you can try harder then.

'Even the army lets the general down and has to try harder the next time.'

And it would be over.

I go back everyday – bringing treats for her to eat – she recognises me and although she cannot speak, she squeezes my hand and is clearly happy to see me there. We are in a bubble – my focus entirely on my mother – reading to her every day.

This sequestered – sheltered moment is about to be – dissolved.
Irrevocably.

I am feeding mother some khauksue, when a group of young men, again with red headbands, approach me. They are shy and deferential, but clearly determined.

I see Burma is about to have a revolution and would I speak to the students...would I come? Would I give my name?

SUU sees the young men and chides them:

'I am too busy – can't you see. I have to look after my mother!'

But they come back, every day.

Mother is well enough to go home and now the young men gather outside my house.

The collapse of the currency earlier in the year had set a time-bomb ticking. People – *most* of the people – are angry.

You can feel the tension snapping in the air and I am suddenly very afraid.
Afraid of what might happen – afraid I won't measure up. Measure up to their wild expectations.

I am brushing Mother's hair and turning over and over in my mind – I have to decide.

She would never tolerate fear – if you were frightened, you had to confront those fears instantly.

(*Direct and intimate with the audience.*) As a child, I was terrified of the dark and couldn't sleep without a light. My younger brother, Aung Li, would creep out of his bed, blow out my night light and with the claw of one of his more gruesome puppets, tickle my nose.
The scream he got, every time, was, for him, most satisfying.
I was determined to confront my fear of the dark and what the dark contained

– ghosts and demons and worst of all – Nats –
the most powerful of Burmese deities.
One night, I got up and slipped out. Aung Li was
snuffling like a puppy, but he did not stir… I crept out,
determined to meet a demon and stare it down.
I nearly died, when turning down a passage, I saw a tall
figure shuffling towards me.
It was Grandfather on his way back from the bathroom.
He nodded conspiratorially and without a word
disappeared into his room.

I padded down the staircase, my heart thumping in my
chest.

I jumped at every floorboard creak and every croaking
frog.

I threw myself, arms flailing, into the darkest corners
– and yet – after two weeks of nightly forays – found
not one ghost or demon.

So, confronting my fears, I tell the students I will do
whatever duty required.

It is early August – I am writing a letter to you,
Michael, when Maung Htoo shows in a young man. I
had seen him before – at the hospital.
He is sweating and his eyes glitter with excitement and
a kind of, well…manic joy.

What he tells me will ignite the revolution.

(*As the young man.*) 'On the eighth day of the eighth
month of this year – 1988, there will be an uprising – in
Rangoon and right across the country.
Students will march demanding democracy and human
rights!'

I am filled with…what?…his excitement, but also
dread.

Ne Win is as unpredictable as a rhino and twice as dangerous.
Power is his skin and he will not slough it without the greatest convulsion.

(*As herself.*) 'You must be jolly careful. You are taking the greatest risks.
You have my support.
But I cannot leave my mother for the moment. She has a high fever.

You must go.
Keep in touch.
Good luck.'

He leaves with a smile and…

*She sees him make a clenched fist salute, which she returns
– a little embarrassed at such a clichéd gesture.*

Disappearing in a cloud of dust, speeding off on an old green vespa.

Two days later, I hear the gunfire.

SUU bows her head in pain.

The sound of machine gun fire is very distant. It builds throughout this speech.

Father – I have seen – I have…
The Tatmadaw – the Burmese army – established by you father – to free the people, first from the British and then from the Japanese – it is now to become the oppressor – to restore tranquility by imposing law and order – 'Nyein, Wut, Pi, Pyar.
Silent, crouched, crushed, flattened.'

I hear the gunfire from the verandah. Machine gun fire –
– relentless –
And the distant cries of the dying.

It seems to go on for at least an hour – then it stops –
only to be heard again, intermittently – like brush fires
catching – as the Tatmadaw hunt down any students
who had escaped their first deadly volleys.
I sit on the steps of my mother's house – frozen.

 SUU sinks to knees and sits.

Then the persistent young man is at my side – covered
in blood – sweat coursing down his face, blackened
with dust. He is shaking.
He grips my arm and tells me again and again:

(*As the young man.*) 'They're killing everyone…they're
all dead…it's not safe…it's not…it's…'

Then he sinks to his knees and weeps.
I hold him. I hold him as he rocks backwards and
forwards. Until there are no tears left.
I order tea and a bowl of water.

 SUU bathes the imaginary young man.

I ask him to tell me exactly what has happened.

He speaks very slowly at first and keeps his eyes firmly
fixed on the ground.

He tells me he is responsible – he had organized the
students.

He had printed the leaflets…printed them from wax
blocks and rolled them out with fluorescent tubes.
His group – the fighting red peacock – was
responsible…but the demonstration was peaceful…they
just sat down…sat down in the square, in front of the
Town Hall.
Just sat down.

His eyes blink away tears.

 SUU enters the memory.

They are sitting in the baking sun.

Hours pass.

They begin to chant…

We hear the students chanting.

(*As the students.*) 'Partizo democrazi senet tu do ye – Do
ye! Do ye!
Democracy – it is people's business – Do ye! Do ye!
Panzi jaona pianloye, Do ye! Do ye!
Release all political prisoners – Do ye! Do ye!'

They even share their food with the soldiers guarding
the Town Hall, as the hours wear on.
Then someone shouts – 'They're coming!'

We hear tanks and soldiers in the distance.

In the distance, they hear the thrum of engines and
the clank of caterpillar tracks – plumes of dirty diesel
smoke puncture the air as the tanks and armoured cars
close off all the exits to the square.

He tells them. He tells them they can go. One street is
still open.

(*As the young man.*) 'Go now. If you want to. Go.'

But most stay. Sitting. Waiting.

Then from behind the vehicles – the rapid clatter
of boots – and soldiers now form a solid dark green
barrier across every junction.

The students are trapped.

The sun glints on the bayonets.

No one moves.

Nothing moves.

The sun shines.

Then someone…no one knows who – begins…

(*As the students, chanting.*) 'Pi du seta – do seta

People's Soldiers! People's Soldiers!

Don't shoot! Don't shoot!'

Over and over – till the rhythmic cry fills the air.

The young man sitting on my porch stops. His voice
falling to a whisper.

His sister, a girl of fourteen – she had followed him
from home – suddenly she grabs his flag – his red
fighting peacock – and runs – Runs right towards the
nearest tank.

> *SUU takes the blanket and it becomes the flag of the
> revolution.*

And up – onto the turret and planting her banner on
the tank she shouts at the top of her voice:

(*Crying out in Burmese, as the young girl.*) 'People's
Soldiers! Don't shoot!

You are our brothers – you are our brothers!'

She is shouting into the face of a young soldier – his
hand closes on the trigger of the machine gun, fixed to
his turret.

There is a moment of silence.

> *A machine-gun burst.*

She takes it full in the chest and flies backwards through
the air.
Her body hits the ground – dead – like a rag doll.

Then the square fills with firing. From all sides.

Slowly and with deliberation, the soldiers advance
– bayonets finishing what the bullets had begun.

The young man's eyes are empty –

He tells me he got to his sister.

She lies perfectly still in a crimson pool.

The blanket has now become the body of the girl.

He ties his red fighting peacock headband to her head.
All around him, people are falling. He holds her body.

He would have remained there and died, had not a
fellow student pulled him away.
Pulled him away as far as a tree on the edge of the
square.
He cannot bring himself to leave, but climbs high into
the tree and hides in its dense foliage.

What he sees then – what he witnesses…
Once the soldiers had bayoneted the square, the bodies
are collected – the dead and the barely living – thrown
onto trucks and taken – as I later discovered – for
incineration.
Then fire engines come and hose away the blood.

(*Direct to the audience.*) No one knew about this – almost
no one knew about the thousands dead – killed over
the coming weeks – slaughtered in Rangoon hospital, in
the streets, in the universities… No one knew, because
very few pictures got out of Burma.

*She feels a sudden pain and there is a flash of light as if from
a battery of cameras and the sound of cheering.*

We are at the Shwedagon Pagoda – at Suu's first rally.

She begs for silence.

The speech begins in Burmese as a recording, through a PA system. Suu speaks underneath it in English and then takes over.

Reverend monks and people! This public rally, here at the Sacred Shwedagon Pagoda, is aimed at informing the whole world of the will of the people.
Our purpose is to show that the entire people entertain the keenest desire for a multi-party democratic system of government.

This rally has been made possible by the recent demonstrations spearheaded by the students and even more because they have been willing to sacrifice their lives.
I therefore request you all to observe a minute's silence in order to show our deepest respect for those students who have lost their lives and even more, in order to share the merit of their deeds amongst us all.

Silence.

(*To audience.*) And there in front of me in a line of much more burly young men is my young student. The green vespa. At the conclusion of my speech, he turns and smiles.

This is the August of revolution and everything seems possible.
My head is well and truly above the parapet. I am committed.
And I am the focus. The focus of all the love the people held for you, my father.
It is now mine. The waves of hope, of love…it is intoxicating.
But this heady brew cannot take away the gnawing fear that I might not measure up and worse, that I will lead my people into mortal danger.

She looks out in pain – her mind flooded with the growing memory of the Depayin massacre. She clutches her shoulder.

We hear a faint echo of cries and blows.

As I stand down from the pagoda, a smart man in a bright red and white chequered lungi and very black hair, stops me.

He has a military bearing and looks me straight in the eye.

(*As U Tin Oo.*) 'Good speech Daw Aung San Suu Kyi. Good speech.
We cannot make it alone. We need unity.
I am U Tin Oo. Let us work together.'

I know this name. This man had been Minister of Defence under Ne Win, until he fell from favour.

(*As herself.*) 'Thank you U Tin Oo.'

He turns to go… I touch his arm.

(*As herself.*) 'U Tin Oo, did you meet my father?
Did you know him?'

(*As U Tin Oo.*) 'Of course. A great man.'

(*As herself.*) 'Do you remember a small girl being held.
Held by someone else, but following my father?'

(*As U Tin Oo.*) 'No. But your father would not be disappointed in that little girl.'

And he is gone.

(*Direct to audience.*) It is now September and the junta has re-baptized itself – SLORC.
SLORC – Laughably Orwellian, don't you think?
The State Law and Order Restoration Council.
It leaves such a bitter taste on the tongue.

And what law is being restored? – What kind of order? An order where the law dictates you can spend ten years in prison for hosting an unreported guest.

Meetings and more meetings. Endlessly answering questions from journalists, eager to be in at the beginning of a new democracy.

And now we have a party – the NLD – The National League for Democracy and everywhere the Golden Fighting Peacock is emblazoned on red banners.

The organizing committee – U Tin Oo, U Kui Maung, U Aung Shwe among others – all men of enormous experience, fought a little shy of talking to the world's press – so I am the voice – a voice I lose on more than one occasion – answering the same questions again and again.
At one rally, the government send their hired thugs to disrupt the meeting. They come armed with rotten tomatoes. They are spotted and miraculously shamed into dropping their grenades. The ground is a red mush of tomato skins and pips.

(*To her father.*) Perhaps it was the talisman of my name… *your* name, that saved my dress that day. Who can tell?

Mother…mother was a little better, you know.

I had been able to move her back to the house and I knew this had helped.

But time was…slipping away.

SUU enters the memory, sharing it with the audience.

Christmas is over – A few bizarre neon displays set up in hotel lobbies – the reindeer, the father Christmases – are still twinkling in bright sunlight.
I had had enough of party business and come home early.

The sun is setting and the whole house is suffused with red light – I see that the door is open.

Maung Htoo, is sweeping leaves from the steps. He turns to me and stifles a cry

– he points wordlessly into the darkness of the house.

I leave my briefcase on the veranda and go inside.

The only sounds – the ticking of the clock, the gentle lapping of the water on Inya lake and the cicadas.

I go to her room.

Light from a window – throws a shaft across the hall and slides under her door.

I don't want to go through that door. I don't want to see.

Then I am sitting by her bed.

Her face is as pale as a paper lantern.

I hold her hand. It is so cold.

Thin strands of white hair have fallen across her eyes and gently...gently...

SUU's fingers re-enact this moment...

...I put them back into place.

As a child I would walk round and round her bed and ask her a question every time I got to her feet. She was exhausted after standing all day on the wards, but she never once...not once, refused to answer. And now.

She cannot answer me.

Not a single word.

I get to her feet and they are as cold as ice.

The tea beside her bed is cold. Stone cold on the table.

She looks asleep.

And her face, for the first time, is in repose. As if all the tension in her body has drained away – I look for the gentle rise and fall of her breast.

It is still.

I bend low over her head – hoping, hoping to feel the slightest movement of air.

There is nothing.
She is gone.
I close the door and sit beside the bed, alone in the dark.

Exterior crowds. Buddhist monks chanting.

She addresses her father.

Your beloved wife, my mother – her coffin is followed by what seems to be every man, woman and child in Rangoon. A truly State Funeral.
They bury her beside U Thant.

I pledge to serve the people as my father and mother had done, even unto death.

She is pained.

(*Direct to audience.*) All the time…all the time, since the foundation of the National League for Democracy, SLORC had been quite quiet, but not inactive.
They have passed laws of great ferocity.
A military officer, can, on a whim, sentence you to hard labour, life imprisonment or death.
And an assembly of more than four people could be dispersed with extreme force.

Cicadas…distant music…a dog barking.

SUU enters the memory.

The April night is warm. The meeting is over and we are walking back to the bullock carts. Going home from Danubya.
We walk, casually, slowly, down the centre of the road, chatting quietly.

A truck draws up – the clatter of boots.

A line of soldiers block our way. A lieutenant, no more than twenty years of age, stands in front of his men. His face rigid.

He screams at us –

The lieutenant shouts an order in Burmese and SUU translates.

(*As the lieutenant.*) 'Go back! Go back! You will be shot! Go back!'

I tell my companions to move onto the pavement.

It isn't courage. It is practical. If lives are to be put at risk, it will be mine alone.

But I'm not going to be intimidated either.

Pause.

I can feel mother – standing by my side.

I start to walk.

As AUNG SAN SUU KYI walks downstage...

The guns are cocked.

She keeps walking.

She pauses for a second and then continues to walk.

The order to fire is countermanded in Burmese.

At the very last moment, a senior officer orders the soldiers to stand down.

I had faced the demons once again and they were not there.

(*Direct to audience.*) I walked through the line and so did my companions, every one.

But, I saw now, with absolute clarity, that I was a
person who would attract trouble wherever I went and
whatever I did.
I had to ensure that my companions were safe. I had to
be careful.

My plan to lay a wreath at the memorial on martyr's
day was just too dangerous.
I cancelled the wreath laying. I would not lead my
people into a killing field on the day my father and his
cabinet were assassinated.

The next day – I am placed under house arrest
– 20th July 1989.

'Chop off the head and limbs are useless.'
Everyone – the '*limbs*' – end up in prison.
Everyone – except me.
This is intolerable. How can they separate me from the
rest.
This will not stand.
I start a hunger strike to force SLORC to either allow
me to join them or to guarantee none of them would be
tortured.
Of course, the assurances are utterly worthless.

　SUU addresses her husband.

I hold out for thirteen days – thirteen days. Until you
arrive Michael.

You look so worried.
I start to eat.
But neither the hunger strike nor house arrest, are
burdens.
Though you know I love to cook, I can do without
much food – aside, perhaps, from Ben and Jerry's ice
cream and *house arrest* – well I am at home and for the
first time *with time*. Time to think and to meditate.

The years of house arrest – it was a cocoon. I see it
now.
Then they were more afraid – they did not dare to
touch me – boring me to death was the preferred
option.
Perhaps they thought I would just die or settle for a
life of letters, flower arranging and Japanese poetry
– utterly cut off from my people.
Did they really believe that by marrying you, by living
outside Burma, that I was no longer Burmese? That I
would scuttle back to England?
Or ultimately accept the circumscription of my
minutes, hours, days…years.

(*Direct to audience.*) This is the strategy – if I am
rendered invisible, I also become irrelevant.
But I was in for the long haul –
in for the long haul with little or no money.
I have to sell some of my furniture.
The security people sell it for me.
I miss my mother's vase – filled with peacock feathers
– the black vase with the birds flying.
Despite letting these things go, I have barely enough
to eat. Might just as well be on hunger strike again! My
hair begins falling out and I am too weak to get out of
bed.
However, my theory is – if I died of anything, it will
probably be of heart failure, rather than starvation.

 Cheers and clapping and cameras flashing.

A victory. A complete landslide. May 1990.
Everything, Father, you would have wished for. And
Michael, you know…I actually…for a moment, I
actually believe that we could be together in Burma.
SLORC had unbelievably and in usefully blind
arrogance called an election – an election they thought
they could buy.

But they *lost*, even in the military areas – even the jailors in Insein had voted NLD, signalling their support to prisoners with thumbs up and reports of seats tumbling to the NLD like dominoes.
And we had done nothing more violent than bang the keys of a typewriter to publicize our manifesto! A manifesto of non-violence!

The clapping and cheering fades.

Euphoria is extinguished within days.
SLORC had no intention of honouring the results.
NLD MPs flee or are arrested. Perhaps it was a trap after all.

I remain where I was.

Pachelbel's canon plays as underscore on an old piano.

For a time the piano is my salvation. I could never manage Scarlatti, but Pachelbel's canon was a favourite. It was your favorite too, Michael. Last thing I played before you had to leave Burma.

You were always very complimentary about my playing, but really the combination of Burmese tuning, the damp and my rudimentary skill wouldn't have made much of a concert.
Still – people were, I am told, comforted. They used to stand outside the gates to listen. I tried to vary the programme, according to the time of day. At least they could be fairly sure I was still alive and kicking.

The playing ends with a crash.

The piano finally expires when I hear that U Tin Oo has been given four more years' hard labour.
He is like a father to me.

I am so angry. So angry that I thump the keys and break the piano.

I try to control my anger. I try to be aware…I am angry…I am angry. Detach – detach from the moment and the anger can be controlled.

You should have seen it Michael. Your quizzical eyebrow would have been enough to make me smile. Might have saved the piano too.

Oh Michael. Michael. Do you remember that favourite photo – the one with us sitting together in Burma? 1970…'73. Can you see how close we are?
How much in love.
You were my very own rock. And now you're gone.

I couldn't be with you.
Could I? Michael?
You always said you knew that my people would come first. You always knew that.
And that's why. Why I had to stay. I thought of you every moment – wishing, wishing I could be there – to hold you – to protect you – But Michael, if I had come the door to Burma would have been closed forever. I would have failed utterly.

I begged you to find a new life – find someone else. But you refused.
You were always so stubborn. You never gave up.

You wooed me with a daily barrage of letters
– wonderful, tender letters; I was swept away by a snowstorm of airmail from Bhutan.
And our wedding… Oh Michael, you looked so smart in your suit.

And then off to Thimphu.
The day of my arrival, remember?

We raced over to the balcony and looked out – such a view – endless, high, white mountains.

We were so happy – with your puppy yapping round our legs.
Oh Lord, that dog – that puppy called '*puppy*'. How long did it take you to dream up that name?

He must be a very old puppy now.

And what of our sons?
Alexander and Kim. I have that last photo I took – they are both so tall.
Kim would be…what? Twenty-six maybe?
And Alexander. He is a man.
They have made me a grandmother twice over.

But I have not, could not be a mother to them.
Sometimes I wonder what I have…
…but I feel that I…to only have their pictures…and now…not even that…

I miss my boys.

But they were both safe with you Michael.
And they have never had to stand outside the prison wire, as countless Burmese children must, who poke desperate fingers through *that* wire to feel the slightest touch of their mother's hand.

I could have kept in touch. But only at SLORC's pleasure.
This was unacceptable.
I could have left Burma.
I will not do so.

My family is safe.

The memory of Depayin fades in.

Desperate, SUU tries to shut it out…

48

Oxford. Damp, misty Oxford. Autumn Oxford.
Michaelmas Term was my special favourite.

The distant sound of Depayin returns. She shuts it out. The
pain of her injuries return.

Oxford. Oxford.
Mother was determined that I try.
Father – you would have approved.
The coolest shade – the great cedar tree in the gardens
of St Hugh's.
Summer days spent reading in the shade of that great
tree.

The bell chime of St Hugh's is heard faintly leading into a
barrage of corks and the sounds of punting.

Winter evenings in the library – gazing distractedly at
the naked trees.
I could never work up any enthusiasm for the elasticity
of supply and demand.

It passed as a golden dream.

The weeks after finals – on the river – punting – a vital
skill mastered in the first year – Absolutely de rigueur
and had to be conquered.
Nothing worse for an undergrad than to be caught
desperately pushing a pole into the Cherwell mud and
moving precisely nowhere.

SUU laughs.

I was the swan of punting – an incarnation of the divine
Hinta – the celestial swan of Burma.
Those early morning forays in the mist – with the water
running down my arm and gradually, by capillary
action, soaking my lungi – they had paid off.

I crept back to St Hugh's, a happy drowned rat.

Truth to tell, I have always loved water. Water to cool you in the furnace of the Burman sun.

Thingyan – to cool you – the festival of water.

It is a – what? – a Saturnalian experience – everyone bombards everyone else with water. And it must be taken in good part – only women initiate the deluge, but once begun, they must take retaliation without demur.

She splashes the water in her bowl high over her head.

It cools us all down.
The water...
The water.

Emerald cool we may be,
As water in cupped hands,
But oh that we might be
As splinters of glass
In cupped hands.

And though SLORC thinks it has the people in its hands – one day they will be cut by the very thing they regard as weak as water.
It yields without breaking and yet can be a force of unimaginable power.

Water.

It took my youngest brother – Aung Li.
One more grief you have been spared, father, by Death.
Oh Aung Li. You would have stood by me, no matter what.
I feel your absence still.
My only true playfellow and holder of all my childhood secrets.

SUU enters the memory.

I find you face down in the ornamental pond. Your tiny body floats like a lily – nudged gently by the golden carp.

I scream out your name and the gardener comes running. He pulls you out.

Lifts your lifeless body out.

SUU picks up the blanket – like a body.

He tries to help, tries to breathe life into your lungs.
I just stand and howl out your name – Aung Li! …
Aung Li!
Then mother comes running towards us. Sweeps your body into her arms.

I had never seen her cry before.
I never did again.

Sudden sounds of sirens as she remembers the motorcade arriving outside the house.

The generals come to my house – my 'restricted residence' in '94.

My first guests in years.
Without warning, Than Shwe and Khin Nyunt are standing in my living room.
Khin Nyunt, head of Military Intelligence and Than Shwe, the supreme leader of SLORC.

Than Shwe is short and neat in his summer khaki with a chestful of medal ribbons. His hair is brilliantined. He is – sleek.
I am struck by his shoes – the way they reflect the light.
Khin Nyunt is altogether less military – a little crumpled and quieter.
He seems thoroughly embarrassed by the whole interview.

Strange, that they should finally want to speak to me
– the Communist stooge, the CIA plant, the foreign
terrorist, the bigamist, the anti-Buddhist.
But we do not touch on how the Government press
portrays me.

Than Shwe speaks first. He has a curiously musical
voice – mellifluous almost.

(*As Than Shwe.*) 'I regret that you have not been able to
play your full part in national life – Your security was,
of course, paramount.
The need for national security, the need for gradual
change in line with economic progress, the need to
move slowly, to approach democracy with discipline,
the need…'

'*The need…the need*'… How dare this man sit there and
say these things!

I point out that we had won a democratic election,
organized, in fact, by SLORC itself.
But the general simply smiles…

(*As Than Shwe.*) 'All things are possible in the fullness
of time – when the people are ready, but economic
progress must come first and we are making progress.
You are not aware Daw Aung San Suu Kyi, of the
economic progress…we now have over 87 new bridges,
over 36,000 miles of new road, 40,000 basic education
schools, 156 universities…'

And yet the people have barely enough to fill their
bellies.

(*As Than Shwe.*) 'We are in the process of securing
ceasefire agreements with all ethnic groups and
tranquillity is returning to the border states.'

As he speaks, I hear the cries of the dead, the rattle
of machine gun fire, the burning of countless Karen
villages, babies thrown like sacks into fires…

He hints at my release when circumstances permit…

(*As Than Shwe.*) 'Perhaps in time for the year of the
Tourist.
Yes – this is most exciting.
You will not be aware, but the nation is bending every
muscle to prepare for this.
It is our patriotic duty. We will build hotels right across
the nation. Top hotels.
Five stars. And we will attract the very best Western
tourists. We will build…'

We will build.
I have already seen just such a building – through the
barbed wire strung across the back of my garden – a
vast hotel on the other side of Inya lake. Built, more
than likely, with the bones of slaves and the gleaming
road that will take *the very best tourists* to this place will
be built by children, breaking stones in shackles, their
faces caked in dust.

I look into his eyes and they are blank.
His image seems to dissolve into darkness and his eyes
become the eyes of a great spider, sitting deep within
some vast web, decorated with the husks of human
corpses.

His whole body, alert, alert to the slightest quiver of the
web, the slightest quiver of dissent in the land.
Suddenly, they arise as if by some prearranged signal.
Than Shwe has delivered his lecture and is now ready
to go. I think they feel they have won the encounter.

(*Addressing the generals.*) 'I trust that your words will be
shown to be true. The Buddhist ruler must live by truth.

An arrow is straight – a word should be an arrow – it
cannot find two targets.'

Than Shwe smiles again, but his eyes darken. I have
had the last word after all.

(*Direct to the audience.*) How many people has this man
sent to the rope or firing squad with a stroke of his pen?
All in the name of Patriotism.

But he is deluded – every act of violence done to
another – is done to himself.
They may be above human laws, but not above the law
of Karma – the cause will take its effect.
It may take years for this effect to be felt – but the light
of the furthest star falls upon this earth.
It is with an effort of will, that I strive to see these men
as human beings – to see beyond the distorting layers
of pride and fear, greed and arrogance – the web that
smothers the human heart and blocks out the light.
If we are truly to negotiate, I have to advance their
interests in step with my own.
Besides, being enemies – it's so exhausting,

As their convoy speeds away in a cloud of outriders
and sirens and the dust settles on University Avenue,
I am struck again by the emptiness of such displays of
power.
Than Shwe – the nation's *Dalang* – the puppet master
– unable to control the strings of the heart.

Without the people's love, they cannot endure.

 Camera flashes, crowds cheering.

I am finally released from house arrest in July 1995.
And there is so much to do.
I need to see U Tin Oo – deputy chairman of the NLD.
He arrives and looks me up and down.

(*As U Tin Oo.*) 'Hm. No change. Good.'

(*As herself.*) 'Uncle, what took you so long – six years to drive a mile?'

SUU laughs.

We sit together on the same sofa that the generals had occupied a year earlier.

I have little to say – I recount the benefits of meditation and routine.

U Tin Oo smiles and says much the same had been true for him, except that Insein's routine involved sleep broken either by guards insisting on endless headcounts or the sounds of brutal beatings.

(*As U Tin Oo.*) 'The prison Governor was a very funny man. He greeted me on my arrival and said: "You people – you people who are demanding human rights – what will you want next? Nudist camps?"'

Two years free from the confines of my house.
Now the military junta has re-branded itself with a more user-friendly set of letters – SPDC – the State Peace and Development Council.
Apparently, they paid a fortune to a Western PR firm for this triumph of deception.
Peace and Development – so has law and order been restored?
It is a little worrying – perhaps, that they feel the job of intimidation – of crushing the people's desire for democracy – for freedom – for freedom from fear – is done.

Two more years.
Michael died of prostate cancer.
By the time of diagnosis, the cancer had found its way to many parts of Michael's body.

SUU addresses Michael.

When you phoned in those last months…I could barely hear your voice.
And then – never finishing a single conversation before they cut us off.
I see you, Michael, at the other end of the phone – left with silence.

The junta refused you permission to come to me, even as you were dying.
And I could not come to you.

I feel myself begin to fall. And the fall is accelerating. In my dreams.
Accelerating towards something. That some decision has been taken.
Something has shifted – it is as if a great beast has shed one skin and now we see – it has become something darker – more muscular – more deadly.
Than Shwe promotes General Soe Win.
Not insignificant – not simply a shuffling of titles – this Soe Win has form, as it were – it was he who ordered the massacre of students and patients in their beds in Rangoon Hospital in '88.

I hear his first statement on the radio:
(*As Soe Win.*) 'The SPDC will never talk to the NLD and will never hand over power.'
I was suddenly reminded of a most chilling passage
– Orwell – the bit where poor Winston is trapped and forced to listen to O'Brien's political lecture…
something along the lines… 'No one takes power with the idea of relinquishing it…
…the object of power…is power.'

2000 – My attempt to get to speak in Mandalay is blocked – they uncouple my carriage, just as the train set off. A comedy, worthy of the Moustache Brothers, but for the frustration.

My journey to Dala is blocked. I sit for nine days in my car on a bridge.
They have no right to bar my way.
Then house arrest again. Then released, like the caged birds that are sold, only to return to their familiar imprisonment. It was a game and utterly transparent.

2003 – Depayin…

The memory of Depayin floods back.

I am to speak in the village of Depayin.

The full memory of Depayin kicks in. Cicadas.

As SUU remembers – we hear the thugs charging towards the car and the attack begins.

SUU, with a great effort of will, confronts the memory of the attack.

I am to speak in the village of Depayin.
I am in my car – there are perhaps six cars, maybe more.
It it getting dark.
We drive down the road through a large field, just before the village.
I am tired. Nothing is out of the ordinary. It is hot. The air is filled with cicadas.

My eye catches movement to my right, and…and out of the tree line…out of the shadows…suddenly there are hundreds of men…with iron bars, sharpened bamboo staves, stones…and they…they start to attack the cars. Pull people out of the cars and smash them down into the dust.

Bones shatter.

Blood.

Terror.

This is to be the final Act – assassination.

I feel my car rocking from side to side and all the time, they are screaming 'Foreigner!', 'Dirty Foreigner!', 'Whore!'. And it is me. Me!

I am the target, but I have brought us all to this. They are going to kill all of us!

I try to get out. To stop them. To speak to them. I get halfway out – the ground is red.

I can see U Tin Oo…he has been dragged from the car in front of me.

They are pulling him by his hair and beating him… beating him savagely.

They hit his head and he falls. I lose him in the bodies.

How dare they! How dare they assault an elder!

The young men – they are so frightened…but still – they shield me with their bodies.

A hand reaches out and pulls me back into the car.

The noise is like the monsoon beating down on a tin roof.

The smashing of glass –

– cries – howling – hatred…

Faces are pressed right up against the window.

I can see their eyes.

They try to prize open my door!

Suddenly the car accelerates – the forest of bamboo staves seems to part.

I hear screams of rage – stones rain down on the car's roof,

Glass shatters.

Something slams into my head

Darkness…

Pause.

I don't know how long I have been here…

…in Insein.

A pause.

But – that is of no consequence.

No consequence, because whether here in Insein or
under house arrest, I am in for the long haul.

This dress – bloodstained and tattered will bear witness
to the struggle.
I am alive and so long as one soul remains in Burma
who struggles for freedom, I too will struggle.

The hands that tore down the Berlin Wall released the
flood that swept away sixty years of tyranny.

I have never lost hope.

*She picks up the jasmine flowers that have been concealed
behind the bowl and puts them into her hair.*

One day, when we look back at these long days of
struggle and fear – when we reminisce – you and I
– who are gathered here in this place. Me behind the
barbed wire and you peering over the iron gate, we will
laugh at the absurdity of it all.
This is the one privilege that dissidents all over the
world have always had.
When they reflect back upon their courage in the
struggle, they feel elated.
And you too, all of you, will surely feel that way one
day.

The time is near. It is coming.

*The Pachelbel canon fades in as the lights fade down and is
followed by Scarlatti piano music.*

The End.